BRANDENBURGER TOR
WELTFRAGE

(Brandenburg Gate Universal Question)

by
Jörg Immendorff

with a poem
by
A. R. Penck

The Museum of Modern Art, New York

I am here

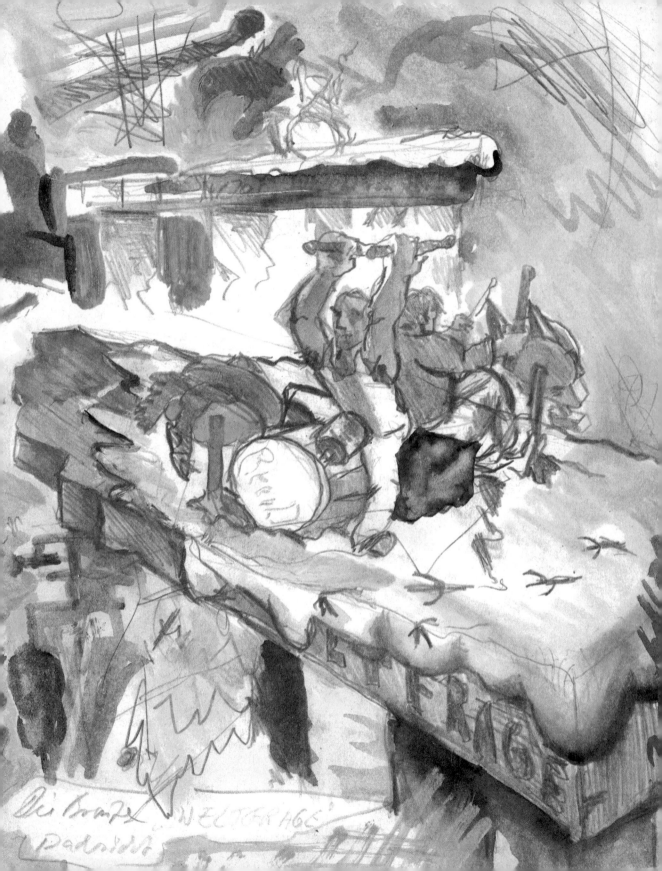

and the generals
too dream
of it

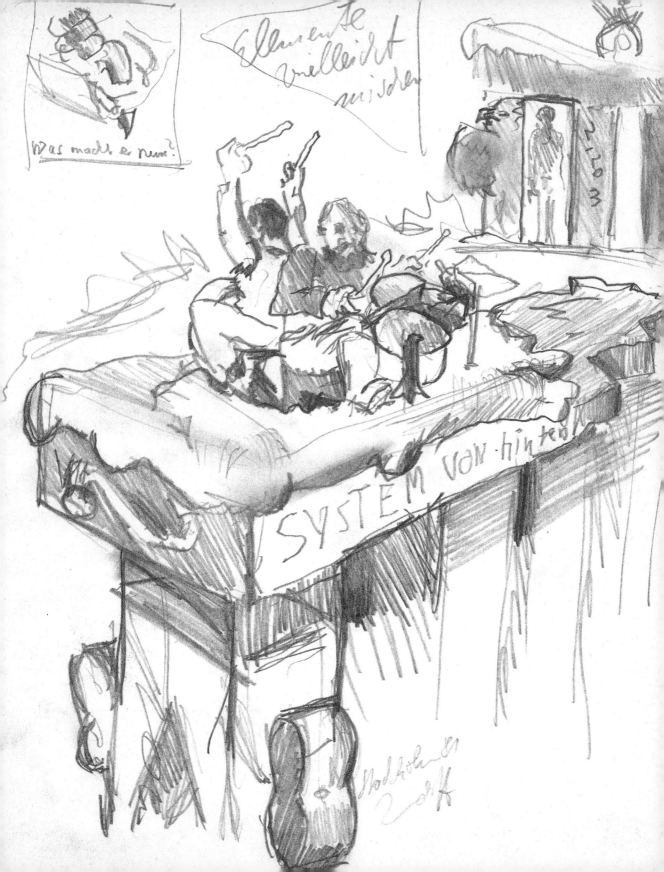

I am the gate

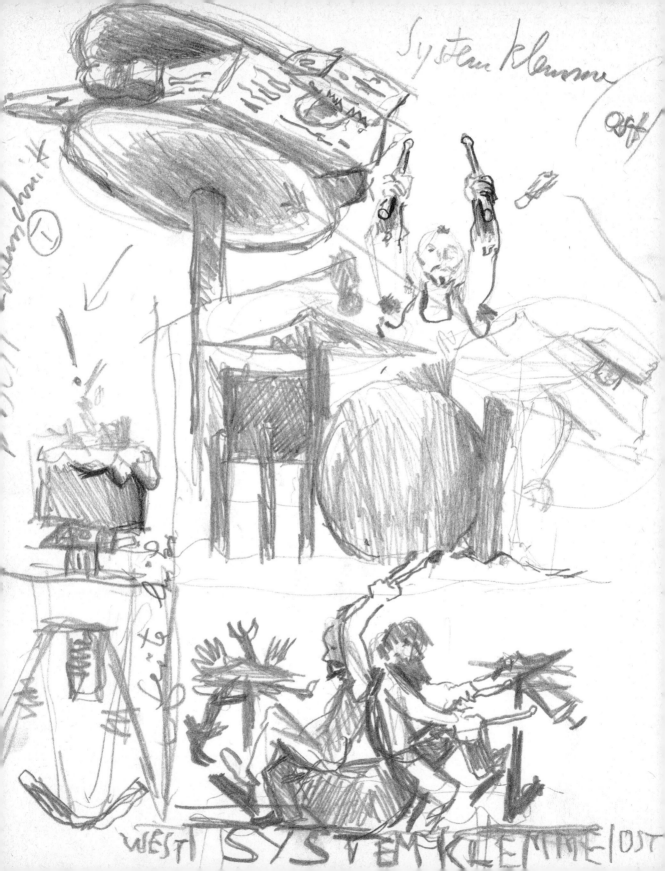

leading

to the future

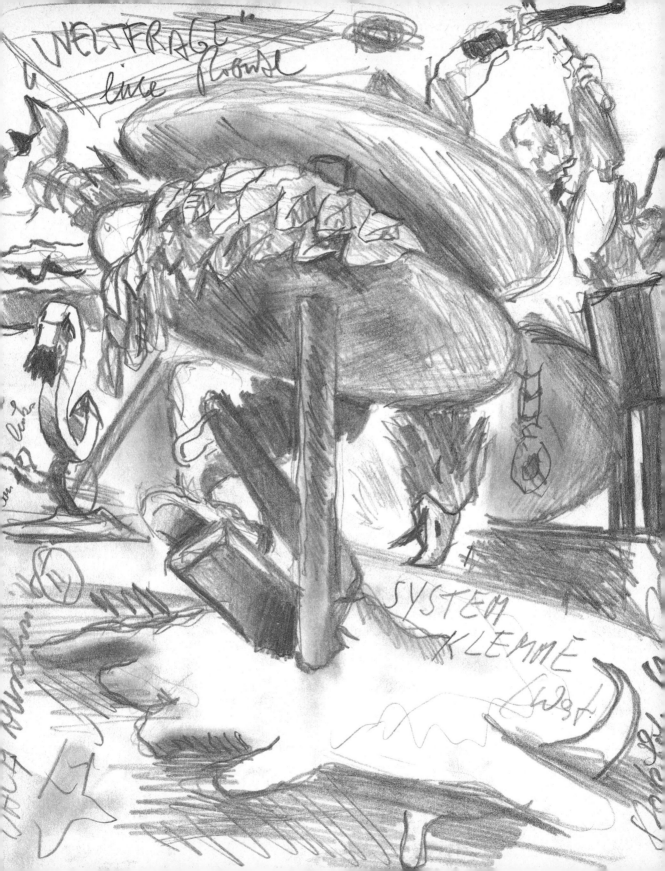

I am the way

into a new

world

I am
the end
of your
illusion

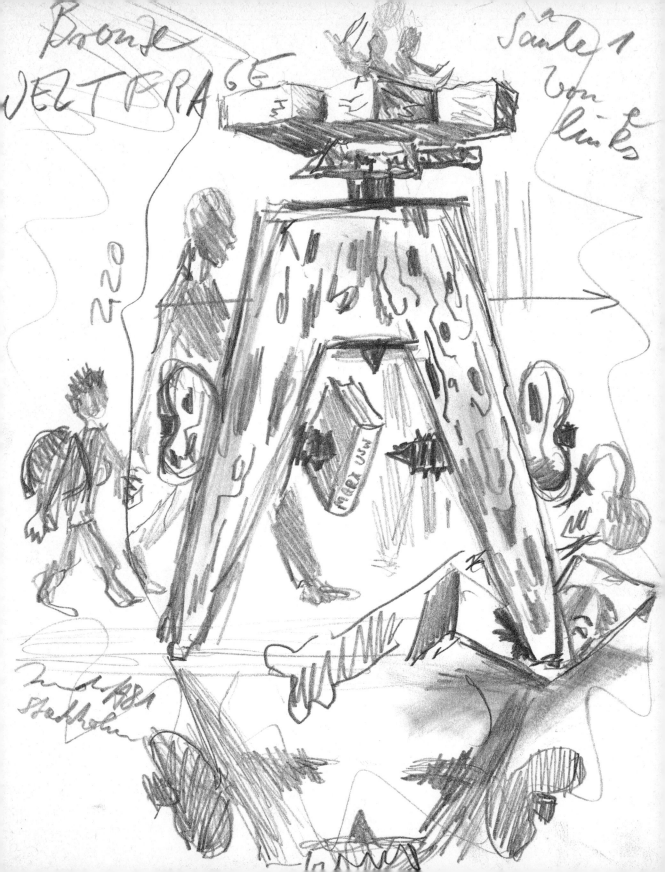

I am
perfectly mad

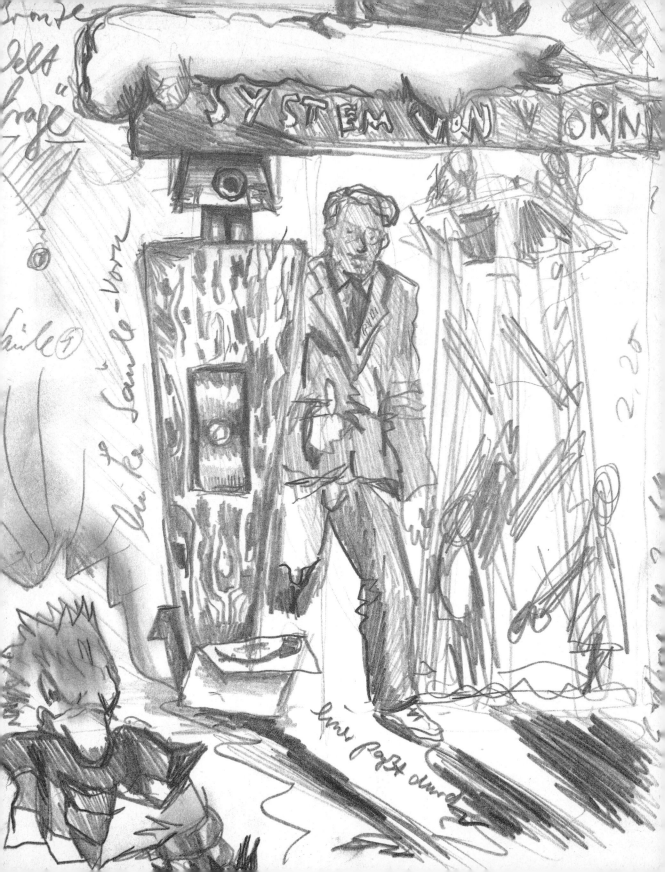

I am
mad
perfect

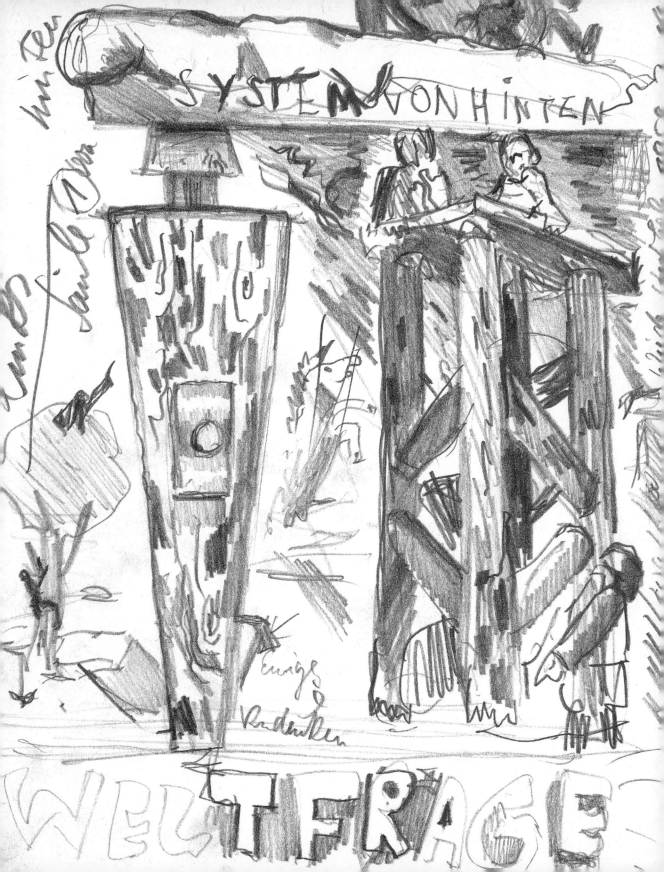

I am
the limit

Komm T RUNTER

now
productivity
decides

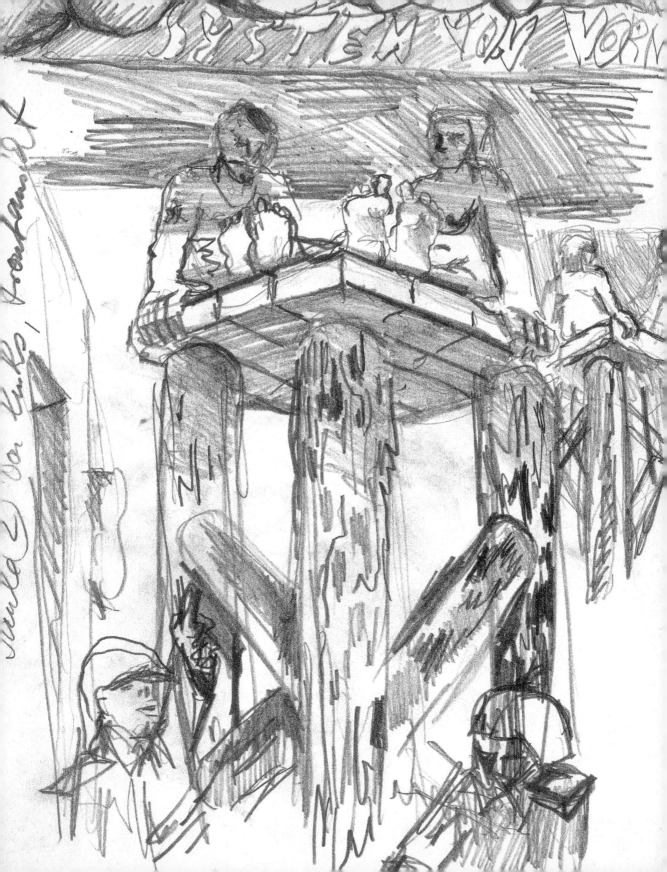

now
creativity
decides

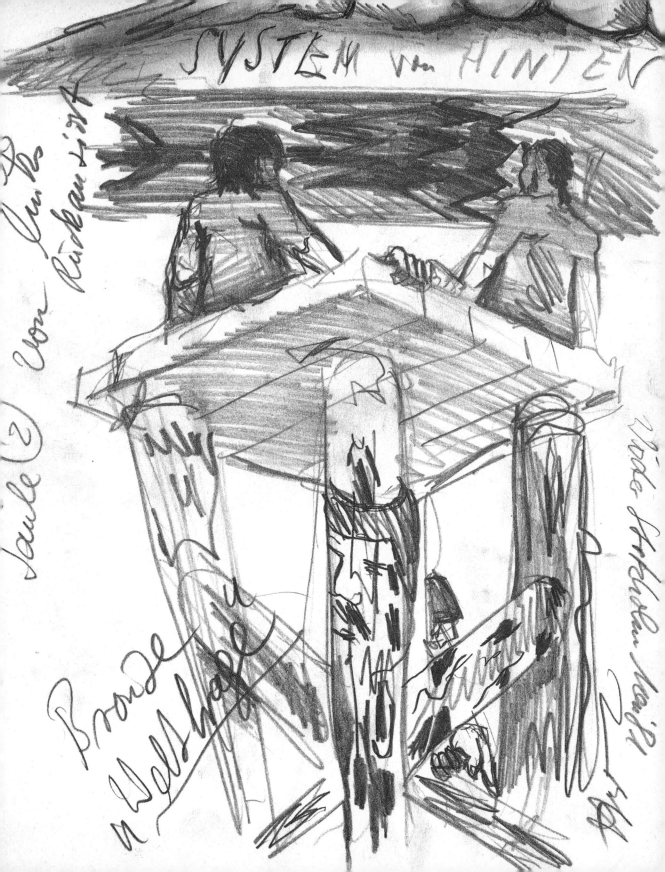

now

contradicting

decides

now

further

thinking

decides

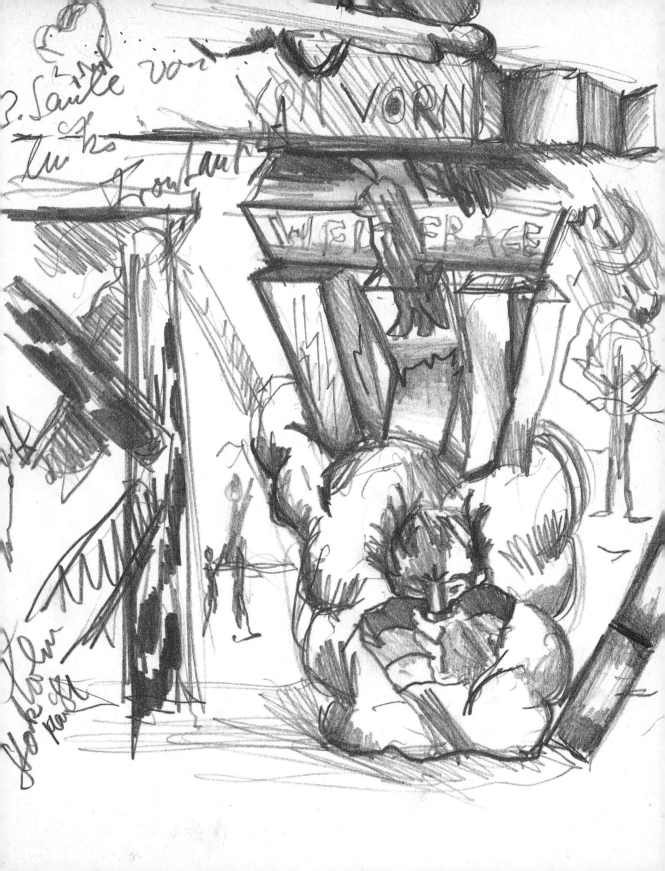

now

further

painting

decides

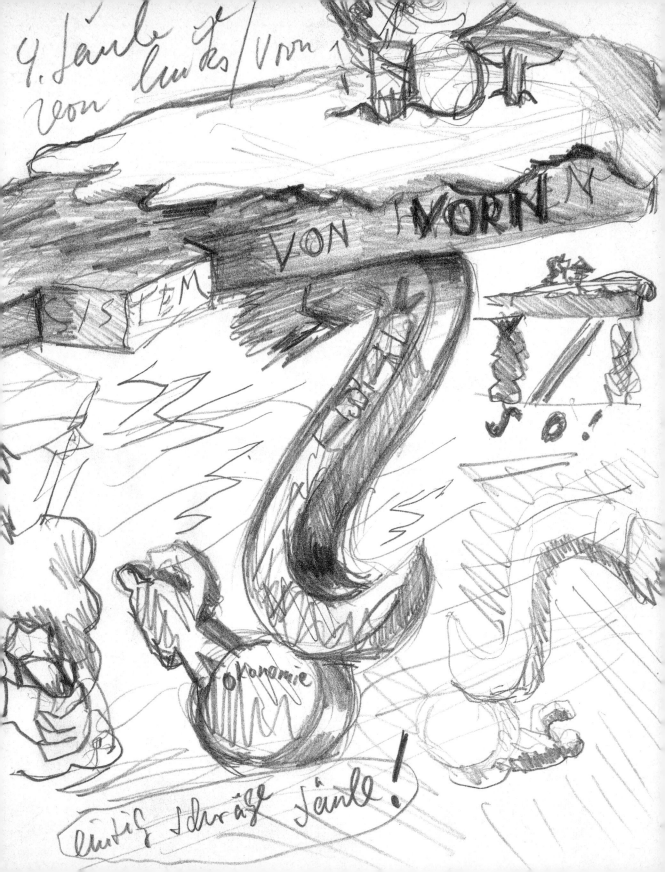

now

further

working

decides

Bronze Wellblech

SYSTEM VON HINTEN

4. Säule
von links
hinten

rechts Fall!
von hinten!

einzig schräge Säule

now

the

deeper pain

decides

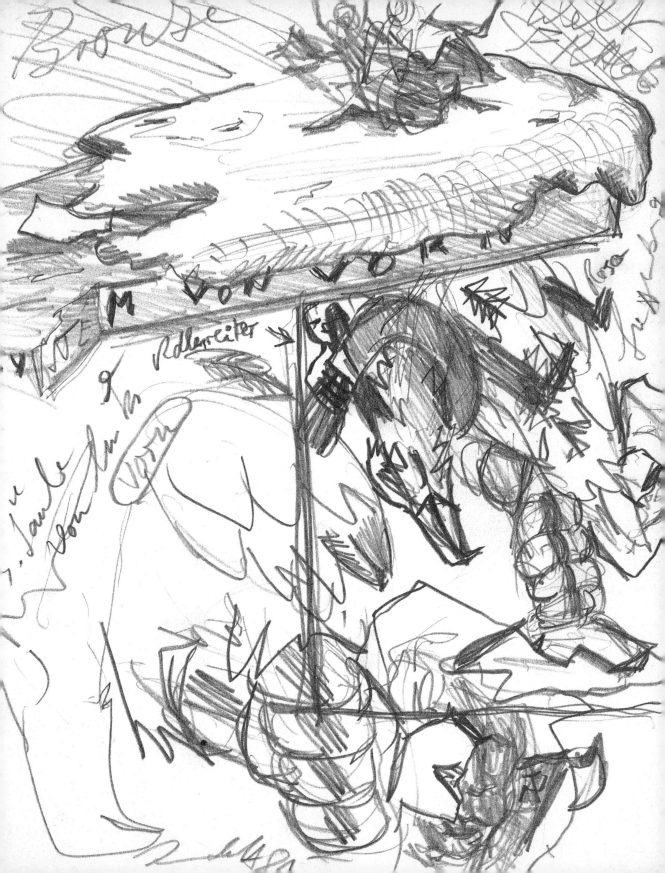

the more

intensive

affection

Beinausschnitt von der 5. Säule von links
der Bronse „Weltfrage

SYSTEM VON VORN

WAS MACHT SIE NUN

not this way

and this way

and this way

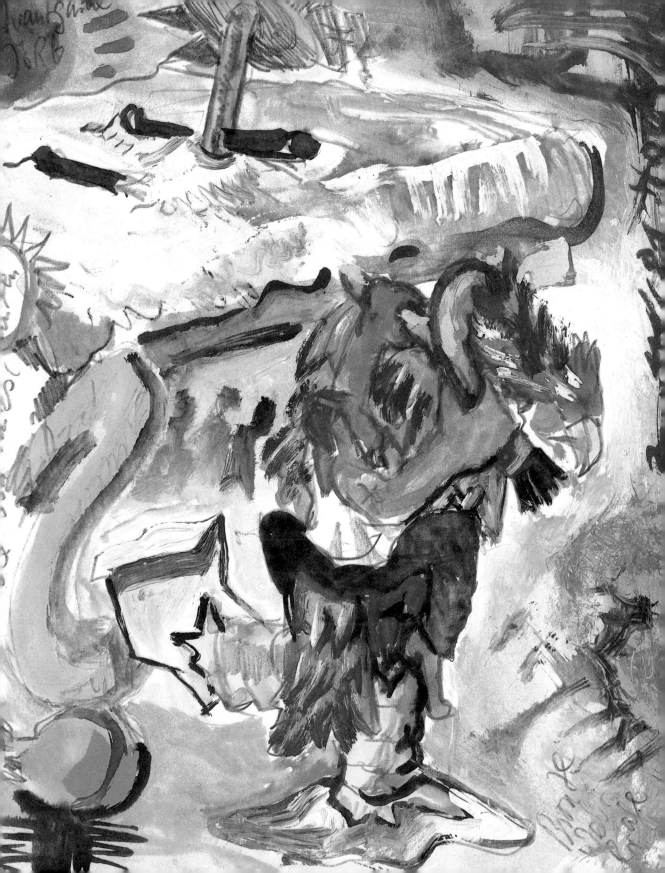

neither with
violence
nor belief

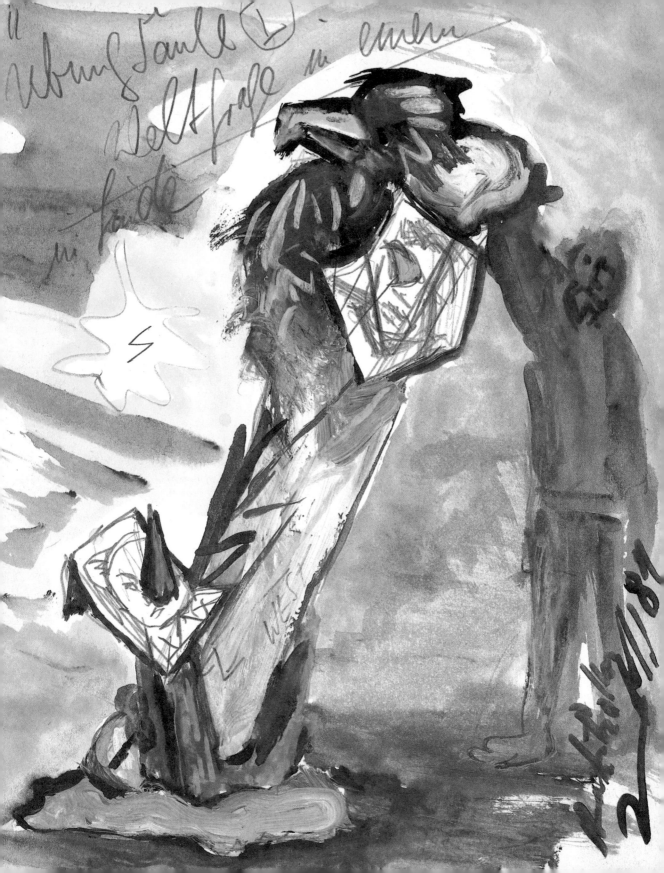

neither
with
obstinacy

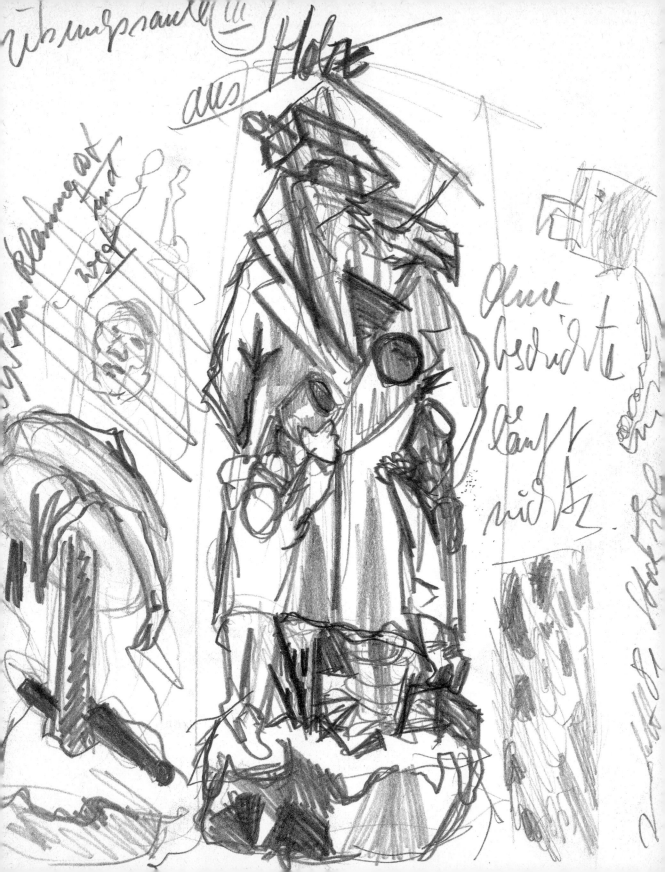

nor
with
shallowness

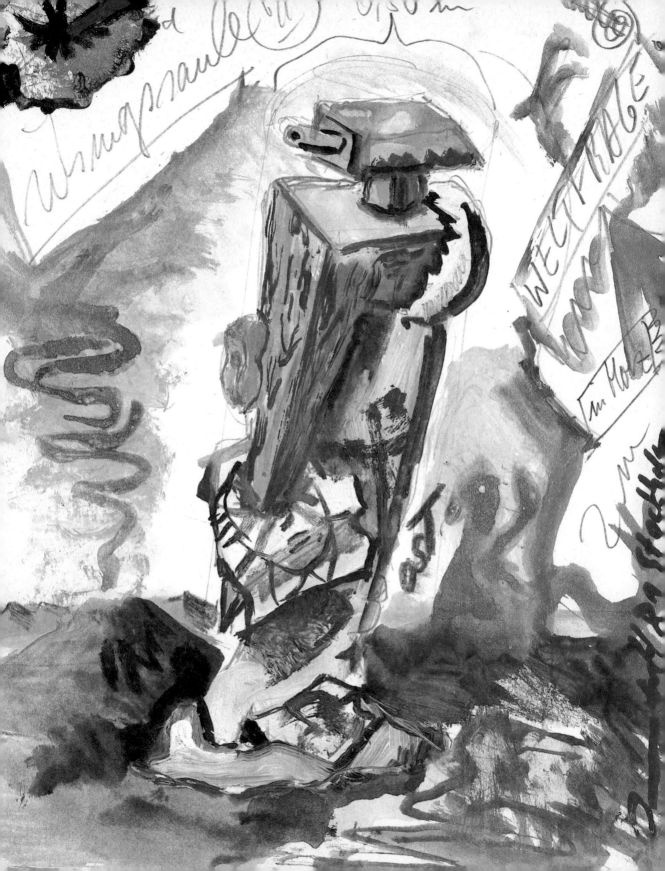

can
we
survive

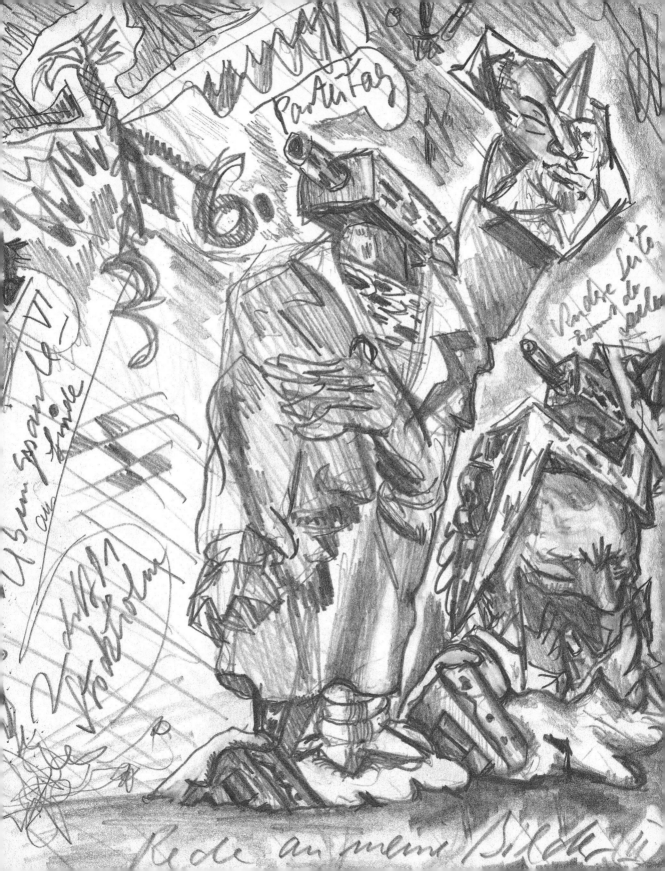

can we creep

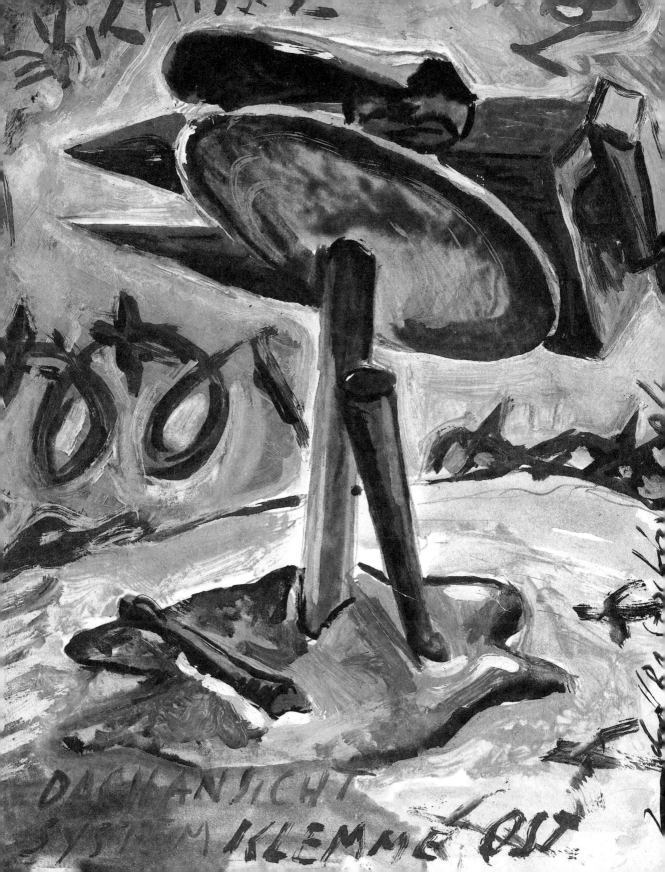

can we skim

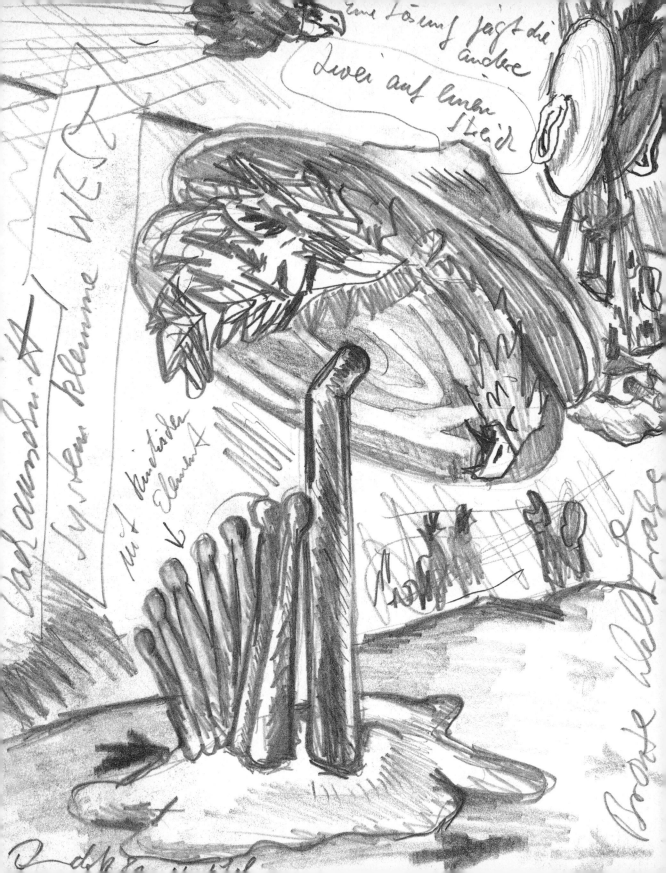

can we

recognize

what is

of importance

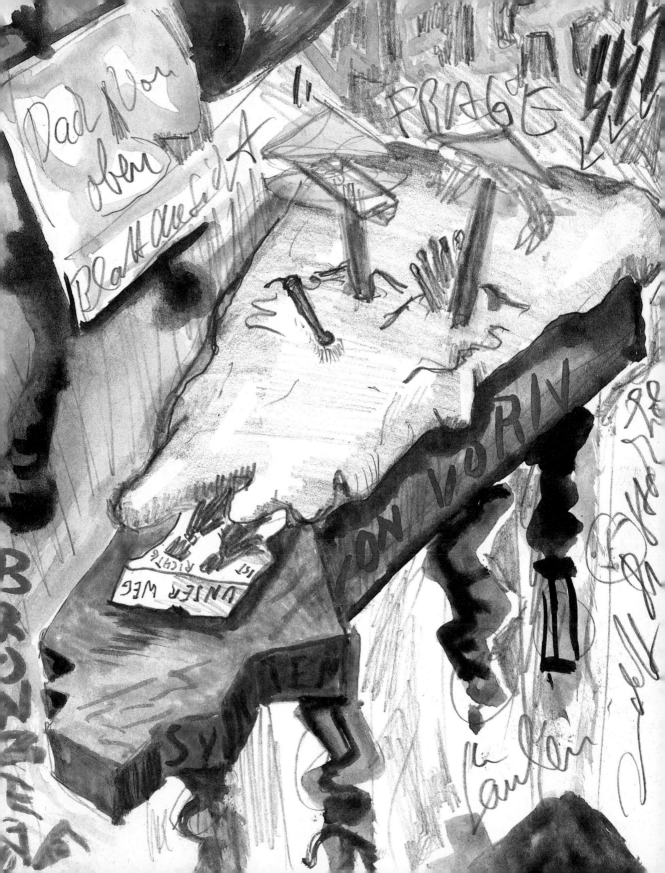

what is

necessary

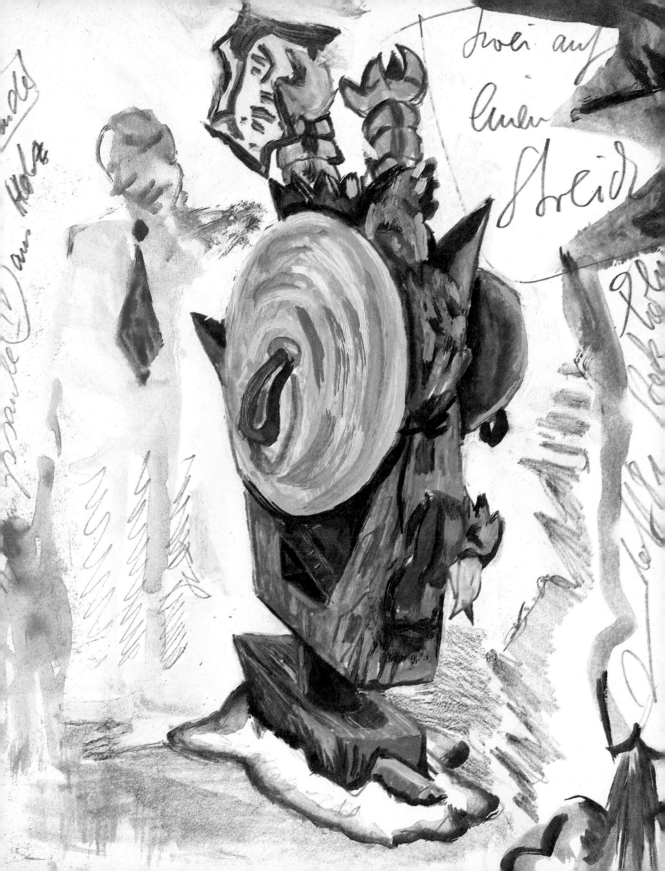

what is good

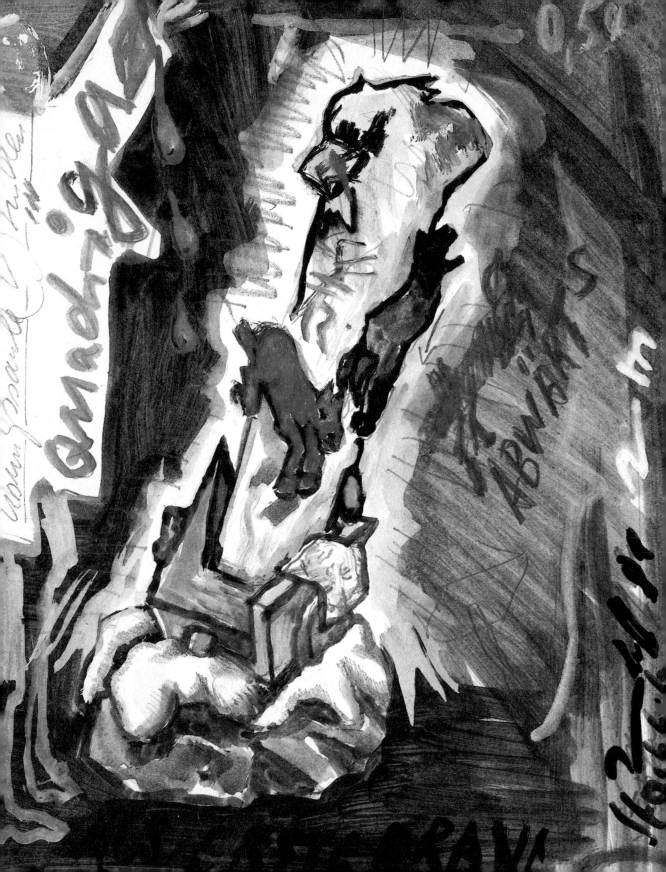

therefore

prepare

yourselves

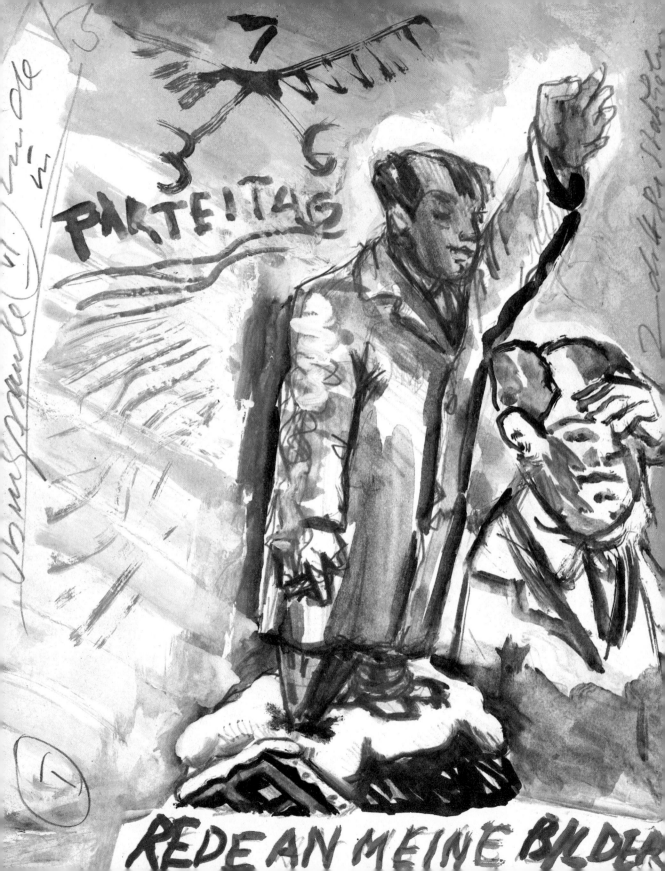

remain flexible

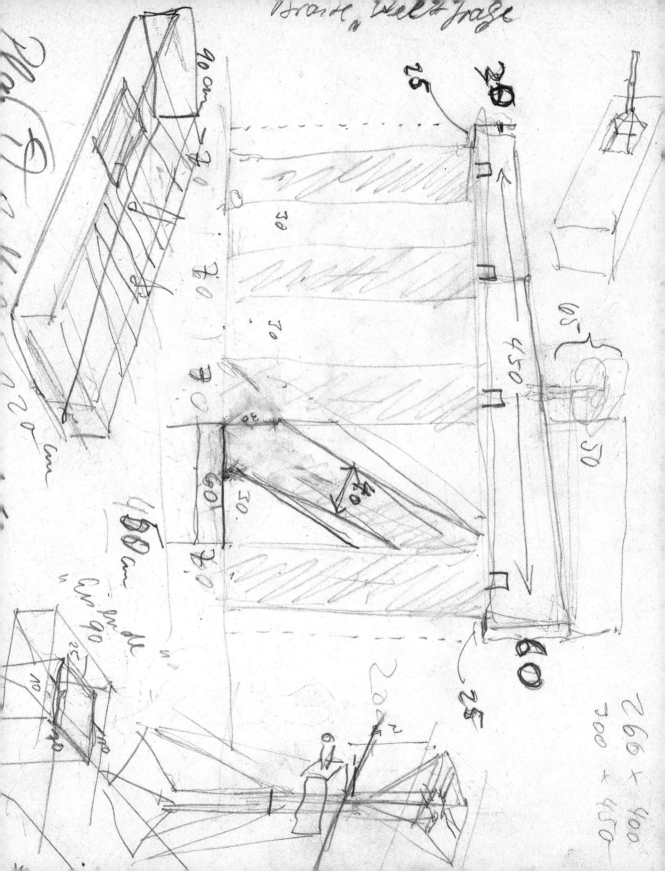

remain awake

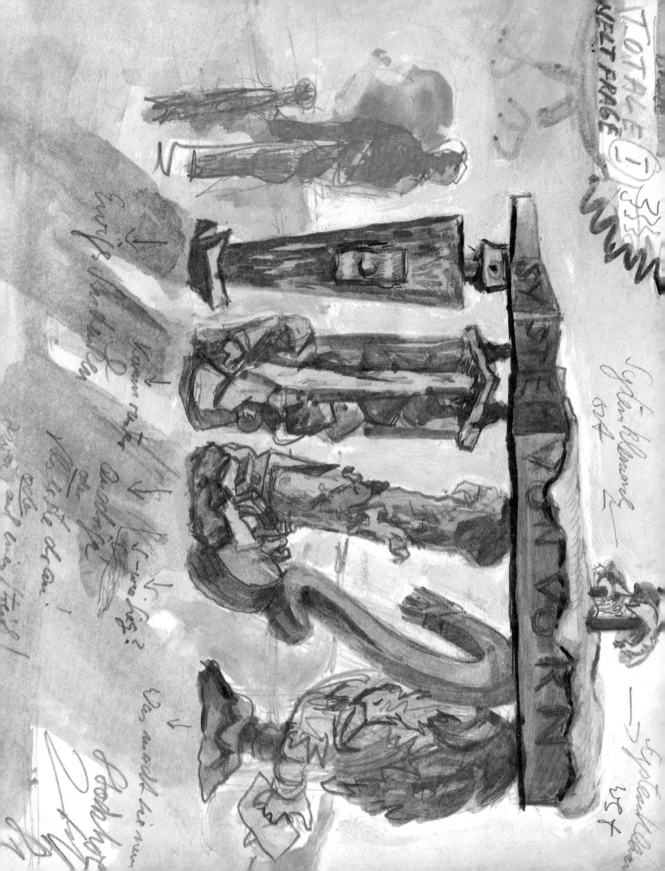

remain
unimpessed

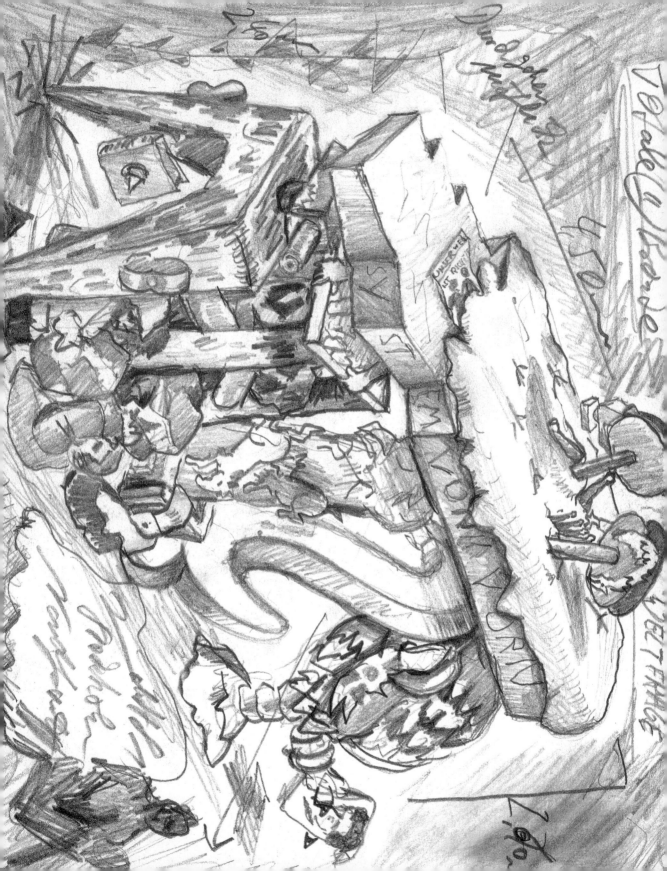

by the ghosts
of the past

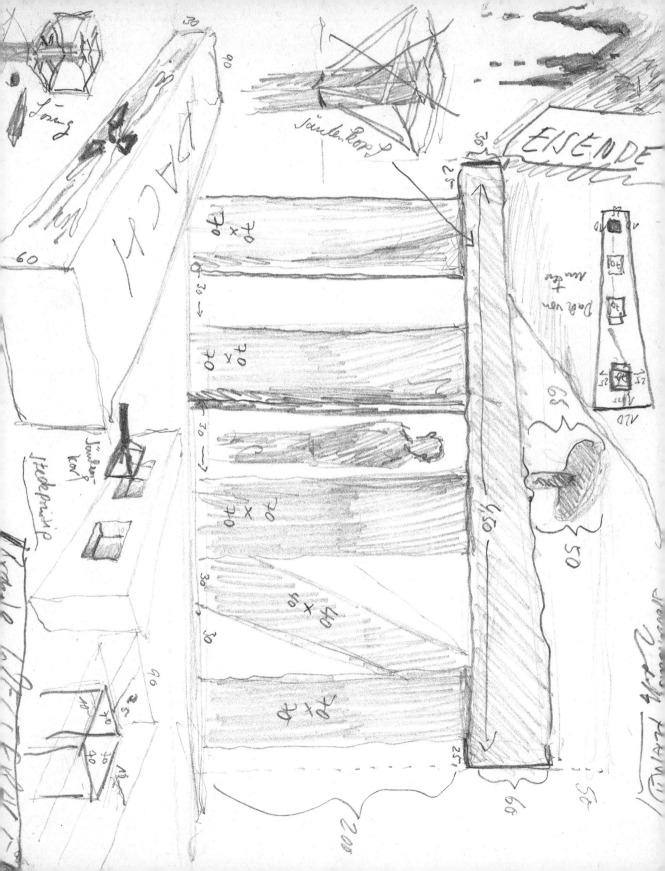

there
is always
a way

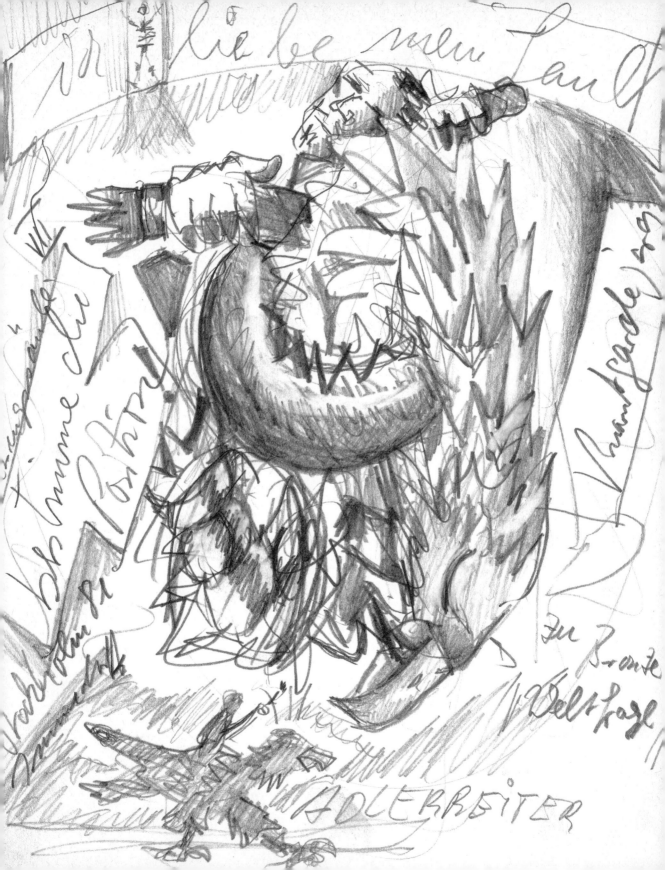

there is

always

a goal

Übungssäule von einstunde

Eisende

In Bronze WELTFRAGE
 (Dad)

EIS ENDE

just skip out
gaily

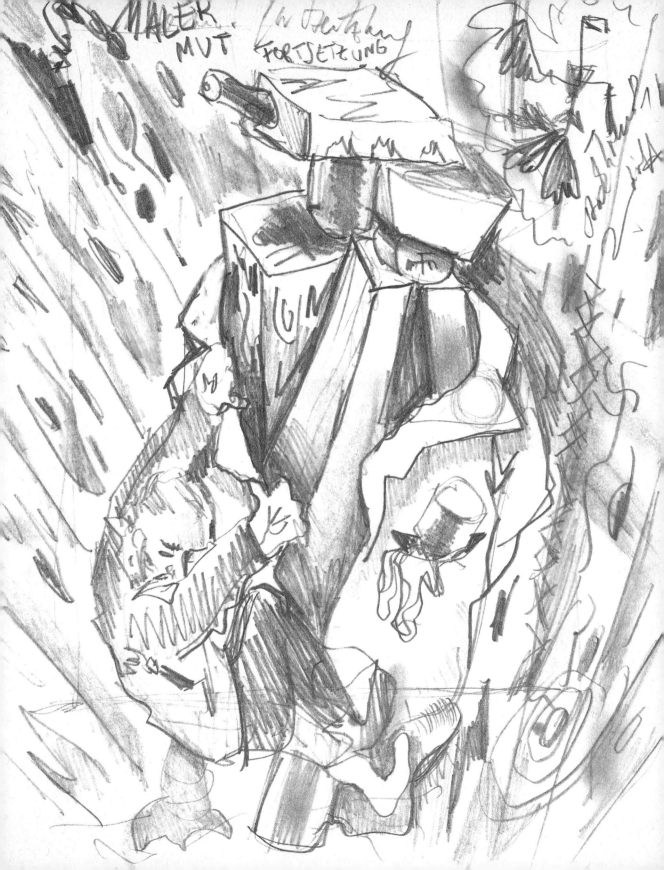

play your
game
loosely

GLOSSARY

Words and phrases that appear in the drawings are listed alphabetically below and translated into English.

Abwärts	Downward
Adler im Staub der Geschichte	Eagle in the dust of history
Adlerreiter	Eagle rider
Allianz der "Creativität"	Alliance for creativity
Beschluss/36. Parteitag	Resolution/1936. Political convention
Bestimme die Position	Determine the position
Dachansicht	Roof view
Dachausschnitt	Roof section
Durchgehen möglich	Possible to pass through
Eine Lösung jagd die andere	One solution chases the other
Einer passt durch	One fits through
Eisende	End of ice
Elemente vielleicht mischen	Perhaps mix elements
Ewiges Andenken	Eternal remembrance
Forsetzung	Continuation
Hier durchgehen	Here one goes through
aus/im Holz	of/in wood
Ich liebe mein Land	I love my country
Kommt runter	Descends
Konzeptionalle Futurismus mit kinetische Elementen	Conceptional Futurism with moving elements
aus Linde	of lindenwood
Lustig schräge Säule	Funny slanting column
Maler	Painter
Massstab von hinten	Scale (drawing) from back
Mut	Courage
Nordfront	North front
Ökonomie	Economy
Ohne Geschichte läuft nichts	Without history nothing works
Ost	East
Parteitag	Party day (political convention)
Planung	Planning
Quadriga oder Als erste dran! oder Zwei auf einem Streich	Quadriga or The first there or Two at one blow
Rede an meine Bilder	Discourse on my paintings
Rückansicht	View from back
Säule	Column
Schräge Säule	Slanting column
Seitenansicht	View from side
Steckprinzip	Fixed principle
S–wie Sieg	V–for victory
System Klemme	Choking system
System von hinten	System seen from the back
System von vorn	System from the front
Übungssäule	Practice column
Unser Weg ist richtig	Our way is right
Was macht er/sie nun?	Well, what is he/she doing?
Weltfrage	Universal problem
Zwei auf einem Streich	Two at one blow

The drawings were made in Stockholm and Eindhoven, 1981.

This publication of The Museum of Modern Art
Projects Program has been made possible through
grants from Agnes Gund Saalfield, the Visual Arts
Services Program of the New York State Council on
the Arts, and the International Council of The
Museum of Modern Art.

Brandenburger Tor drawings courtesy Galerie
Michael Werner, Cologne

The Museum of Modern Art
11 West 53 Street
New York, N.Y. 10019

Typeset by Boro Typographers, Inc., New York
Printed and bound by Amilcare Pizzi, s.p.a., Milan, Italy